William Claxton, 1995
Photo: Len Prince

"Photography is jazz for the eye," says CLAX... ...the ...aphotographer in the world... ...musicians and ...em... ...work is his i... ...and evident... ...with the musicians themselves, plus a rare sensitivity to the sounds around him – in mid-session, the story goes, 'Clax' would always keep his shutter clicks on the beat. Claxton started out around the jazz clubs of his native Los Angeles wielding an already obsolete 4 x 5" Speed Graphic camera. In 1952, while shooting the Gerry Mulligan Quartet with Chet Baker, he met Richard Bock, founder of the fledgling Pacific Jazz label. Claxton became the label's house photographer and art director, designing and shooting many ground-breaking album covers over the next years. Trading the Speed Graphic for a Rolleiflex, Claxton began to

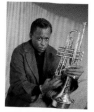

Miles Davis, 1957
Photo: William Claxton

work using only available light. A succession of images flowed through his lens, many of which have since become the definitive icons of the time. Claxton captured not the sound but the soul of the great players – the focused intensity of Miles, the heart and mind of Bill Evans melting into his piano, the fragility of Chet Baker reaching for the microphone, the exuberance of Louis Armstrong. William Claxton's work has been featured in several books since the 1950s, the latest of which, also published by Taschen, is the most comprehensive collection to date. Today, Claxton is still finding new connections with the young musicians on the scene, still finding *the* shot. Listen with your eyes.

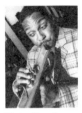

Wynton Marsalis, 1993
Photo: William Claxton

»Fotografie ist Jazz für das Auge.« WILLIAM CLAXTON, der berühmteste Jazz-Fotograf der Welt, wird von Musikern und Fans gleichermaßen geachtet und verehrt. Der Schlüssel zu seinem Werk liegt in dem intensiven Verhältnis, das er zu den Musikern pflegt, und in seiner außerordentlichen Sensibilität für die Klänge, die ihn umgeben – im Verlauf einer Fotosession, so wird erzählt, achtet »Clax« stets darauf, daß das Klicken seines Kameraverschlusses im Takt bleibt. Claxton hat in den Jazzclubs seiner Heimatstadt Los Angeles mit einer schon damals veralteten 4 x 5" Speed-Graphic-Kamera angefangen. Als er 1952 Aufnahmen vom Gerry Mulligan Quartet mit Chet Baker machte, lernte er Richard Bock kennen, den Begründer des jungen, ambitionierten Labels Pacific Jazz. Claxton wurde Art Director des Labels und gestaltete in den folgenden Jahren die Entwürfe für zahlreiche bahnbrechende Plattencover. Nachdem er die Speed Graphic gegen eine Rolleiflex eingetauscht hatte, arbeitete Claxton fortan nur noch mit dem vorhandenen Licht. Zahlreiche Bilder strömten durch seine Linse, und viele davon sind mittlerweile zu Ikonen ihrer Zeit geworden. Claxton hat nicht den Sound, sondern die Seele der großen Musiker eingefangen – die konzentrierte Intensität von Miles Davis, den Einklang von Herz und Verstand, der Bill Evans am Piano gelang, die Zerbrechlichkeit, mit der Chet Baker nach dem Mikrofon griff, die pralle Lebenslust von Louis Armstrong. William Claxtons Werk is seit den 50er Jahren in vielen Büchern veröffentlicht worden, von denen das letzte, gleichfalls bei Taschen erschienen, die bislang umfassendste Sammlung von Fotos zeigt. Auch heute noch entdeckt Claxton immer wieder neue Bezüge zu jungen Szenemusikern, und er ist noch immer auf der Suche nach *der* Aufnahme. Hier lernt das Auge hören.

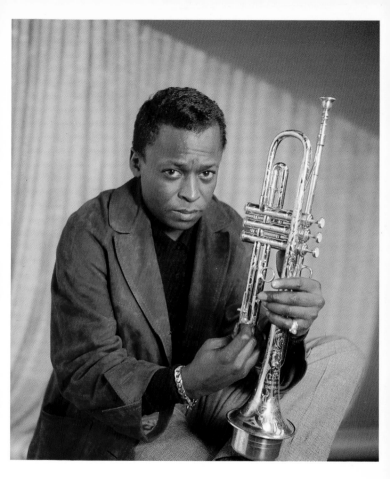

William Claxton
Miles Davis, Hollywood, 1957
from the book:
WILLIAM CLAXTON'S JAZZ PHOTOGRAPHY

TASCHEN

William Claxton
John Coltrane, Guggenheim Museum, New York, 1960
from the book:
WILLIAM CLAXTON'S JAZZ PHOTOGRAPHY

TASCHEN

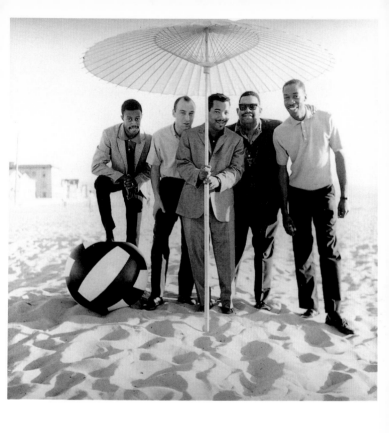

William Claxton
Cannonball Adderley Band, Hermosa Beach, 1956
from the book:
WILLIAM CLAXTON'S JAZZ PHOTOGRAPHY

TASCHEN

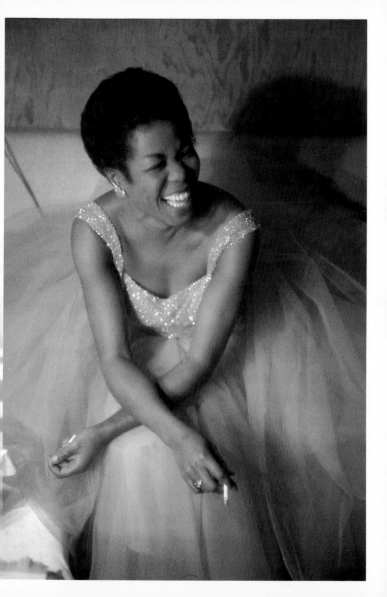

William Claxton
Sarah Vaughan, New York City, 1960
from the book:
WILLIAM CLAXTON'S JAZZ PHOTOGRAPHY

TASCHEN

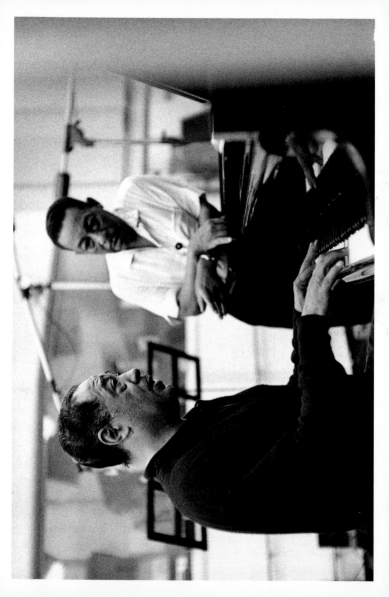

William Claxton
Duke Ellington, Johnny Hodges, Hollywood, 1960
from the book:
WILLIAM CLAXTON'S JAZZ PHOTOGRAPHY

TASCHEN

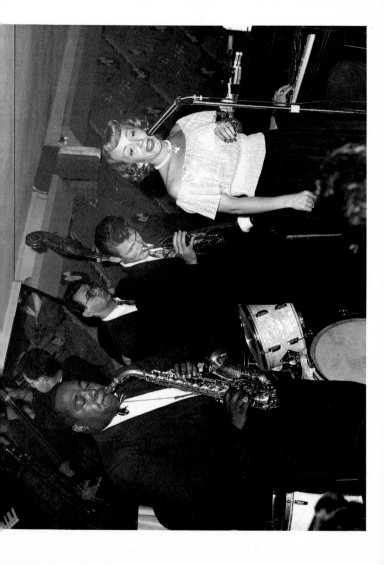

William Claxton
Charlie Parker, Harry Babison, Chet Baker, Helen Carr,
Tiffany Club, Los Angeles, 1951
from the book:
WILLIAM CLAXTON'S JAZZ PHOTOGRAPHY

TASCHEN

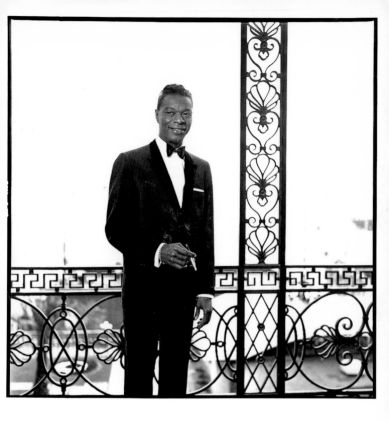

William Claxton
Nat King Cole, San Francisco, 1957
from the book:
WILLIAM CLAXTON'S JAZZ PHOTOGRAPHY

TASCHEN

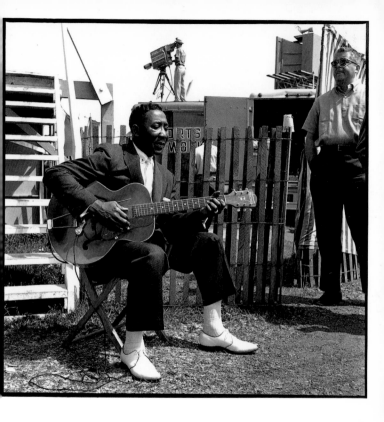

William Claxton
Muddy Waters, Newport, 1960
from the book:
WILLIAM CLAXTON'S JAZZ PHOTOGRAPHY

TASCHEN

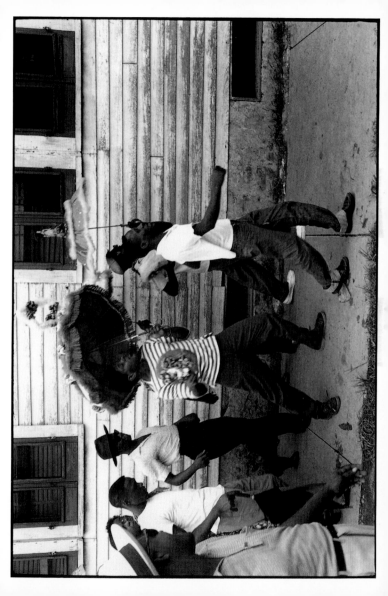

William Claxton
Second Liners, New Orleans, 1960
from the book:
WILLIAM CLAXTON'S JAZZ PHOTOGRAPHY

TASCHEN

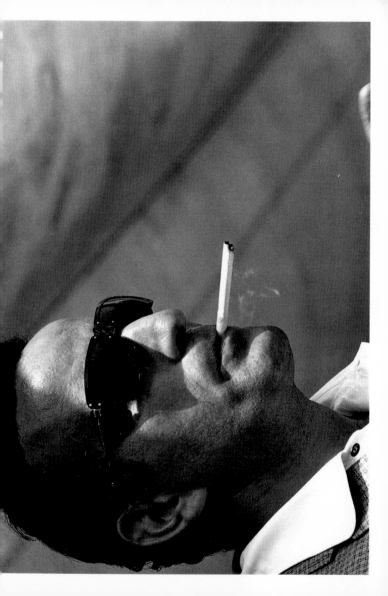

William Claxton
Tony Bennett, Hollywood, 1955
from the book:
WILLIAM CLAXTON'S JAZZ PHOTOGRAPHY

TASCHEN

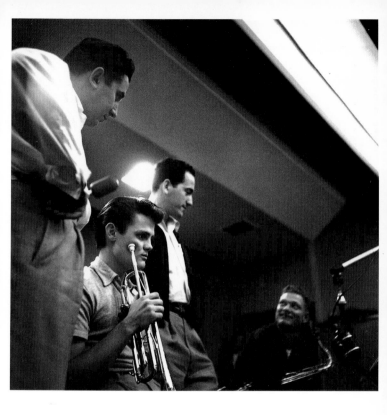

William Claxton
Marty Paich, Chet Baker, Jack Montrose, Zoot Sims, 1954
from the book:
WILLIAM CLAXTON'S JAZZ PHOTOGRAPHY

TASCHEN

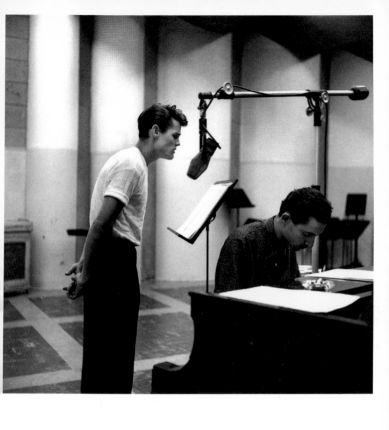

William Claxton
Chet Baker, Russ Freeman, Hollywood, 1954
from the book:
WILLIAM CLAXTON'S JAZZ PHOTOGRAPHY

TASCHEN

William Claxton
Chet's Chops, Hollywood, 1954
from the book:
WILLIAM CLAXTON'S JAZZ PHOTOGRAPHY

TASCHEN

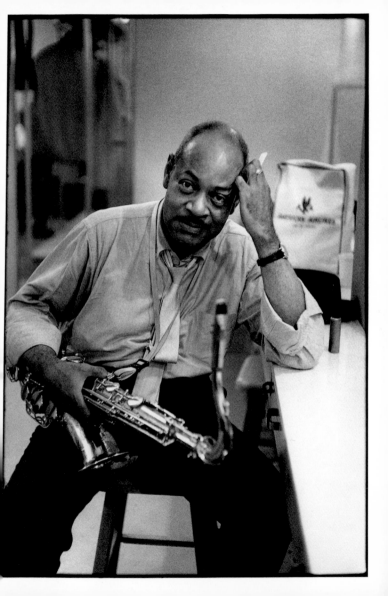

William Claxton
Coleman Hawkins, backstage at the Hollywood Bowl, 1960
from the book:
WILLIAM CLAXTON'S JAZZ PHOTOGRAPHY

TASCHEN

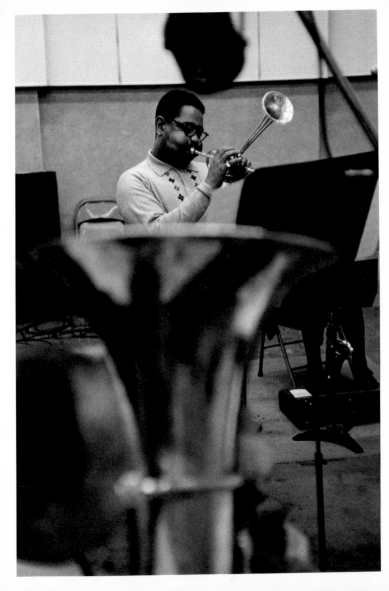

William Claxton
Dizzy Gillespie, New York, 1960
from the book:
WILLIAM CLAXTON'S JAZZ PHOTOGRAPHY

TASCHEN

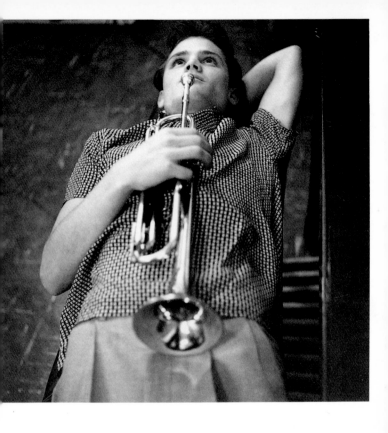

William Claxton
Chet Baker, Hollywood, 1954
from the book:
WILLIAM CLAXTON'S JAZZ PHOTOGRAPHY

TASCHEN

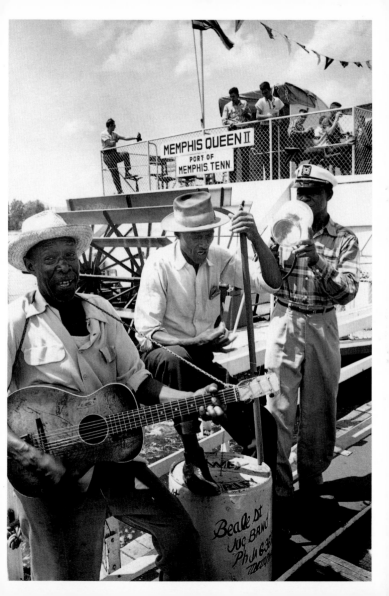

William Claxton
Beale St. Jug Band, New Orleans, 1960
from the book:
WILLIAM CLAXTON'S JAZZ PHOTOGRAPHY

TASCHEN

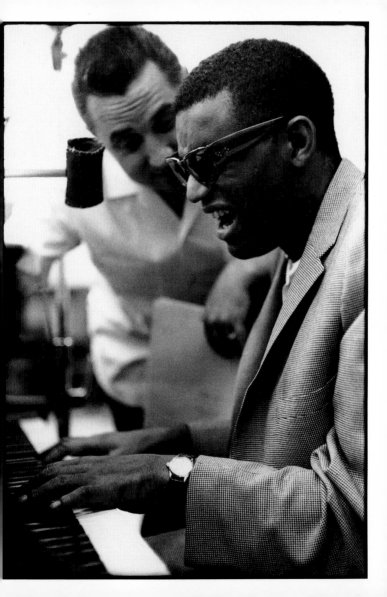

William Claxton
Ray Charles and arranger Marty Paich, Hollywood, 1959
from the book:
WILLIAM CLAXTON'S JAZZ PHOTOGRAPHY

TASCHEN

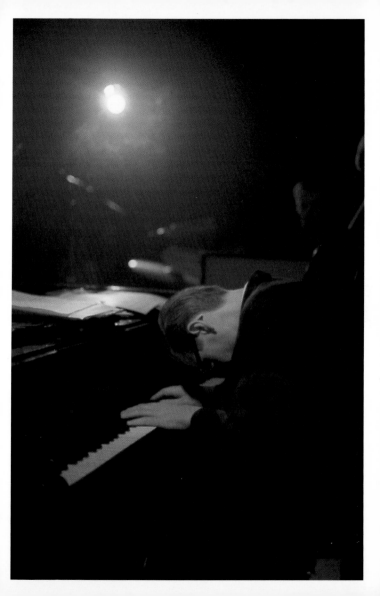

William Claxton
Bill Evans, Hollywood, 1962
from the book:
WILLIAM CLAXTON'S JAZZ PHOTOGRAPHY

TASCHEN

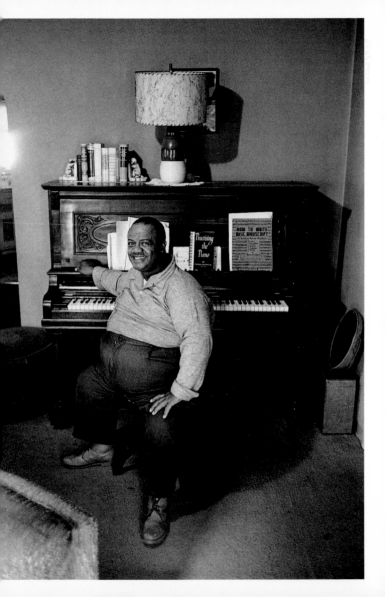

William Claxton
Meade Lux Lewis, Los Angeles, 1960
from the book:
WILLIAM CLAXTON'S JAZZ PHOTOGRAPHY

TASCHEN

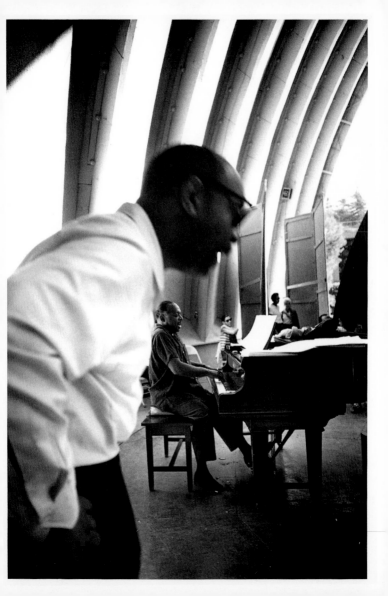

William Claxton
Benny Carter, Count Basie Band, Hollywood Bowl, 1960
from the book:
WILLIAM CLAXTON'S JAZZ PHOTOGRAPHY

TASCHEN

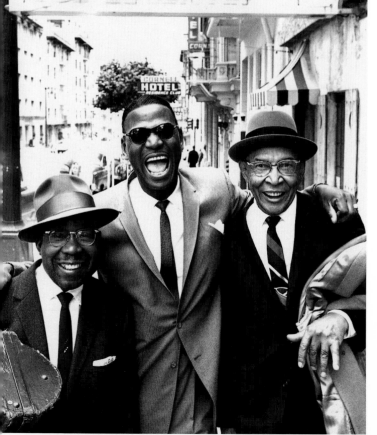

William Claxton
Jimmy Archey, Earl 'Fatha' Hines, Pops Foster,
San Francisco, 1960
from the book:
WILLIAM CLAXTON'S JAZZ PHOTOGRAPHY

TASCHEN

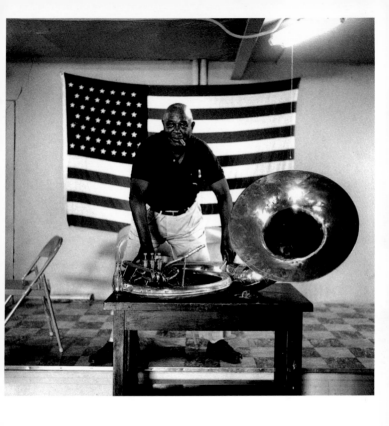

William Claxton
Clint Weaver, Kansas City, 1960
from the book:
WILLIAM CLAXTON'S JAZZ PHOTOGRAPHY

TASCHEN

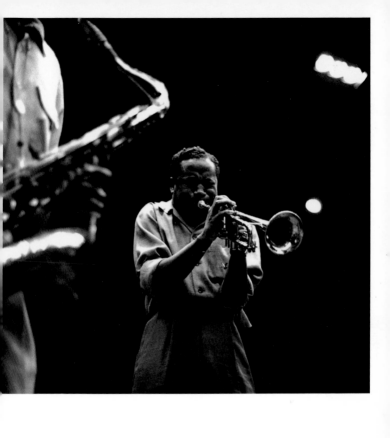

William Claxton
Clifford Brown, Hollywood, 1954
from the book:
WILLIAM CLAXTON'S JAZZ PHOTOGRAPHY

TASCHEN

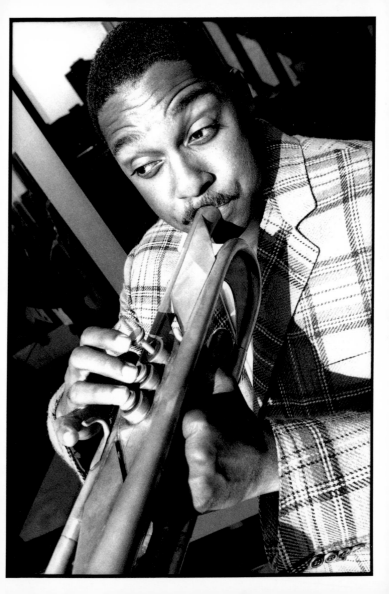

William Claxton
Wynton Marsalis, Lincoln Center, New York, 1993
from the book:
WILLIAM CLAXTON'S JAZZ PHOTOGRAPHY

TASCHEN

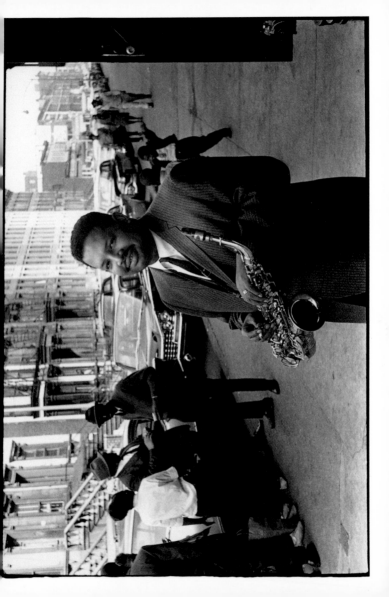

William Claxton
Cannonball Adderley outside Apollo Theatre,
New York City, 1960
from the book:
WILLIAM CLAXTON'S JAZZ PHOTOGRAPHY

TASCHEN

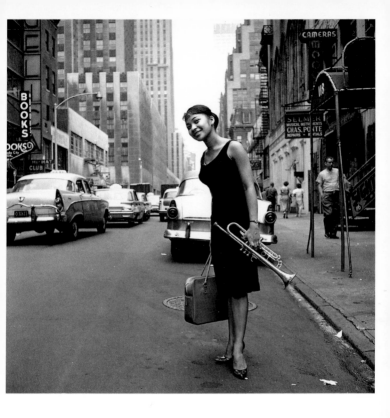

William Claxton
Mrs Donald Byrd, New York, 1959
from the book:
WILLIAM CLAXTON'S JAZZ PHOTOGRAPHY

TASCHEN

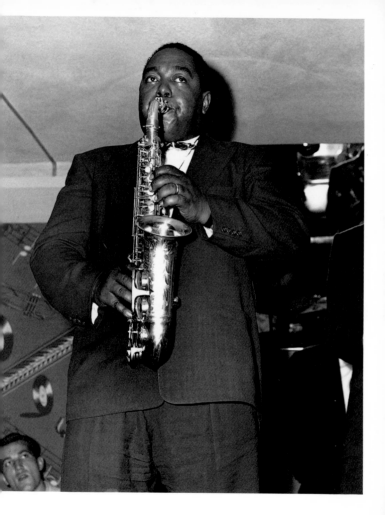

William Claxton
Charlie Parker, Los Angeles, 1951
from the book:
WILLIAM CLAXTON'S JAZZ PHOTOGRAPHY

TASCHEN

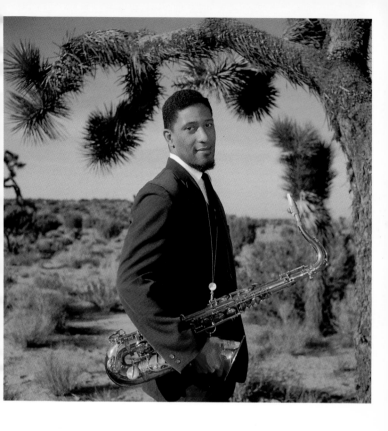

William Claxton
Sonny Rollins, "Way Out West", Mojave Desert, 1955
from the book:
WILLIAM CLAXTON'S JAZZ PHOTOGRAPHY

TASCHEN

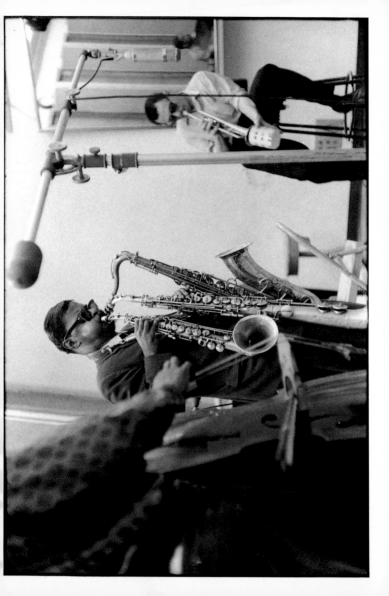

William Claxton
Roland Kirk, New York City, 1959
from the book:
WILLIAM CLAXTON'S JAZZ PHOTOGRAPHY

TASCHEN

Chet singing, 1954
Photo: William Claxton

«*La photographie, c'est du jazz pour l'œil.*» WILLIAM CLAXTON est le photographe de jazz le plus célèbre du monde. Il inspire la même vénération aux musiciens et à leurs admirateurs. Ses clichés témoignent de l'intensité manifeste des rapports qu'il entretient avec les musiciens et de son exceptionnelle sensibilité face aux sonorités ambiantes. On raconte que pendant les improvisations collectives, son appareil crépitait en rythme. Claxton fit ses débuts dans les clubs de jazz de Los Angeles, sa ville natale, muni d'un appareil Speed Graphic 4 x 5" déjà passé de mode. En 1952, alors qu'il photographiait le Gerry Mulligan Quartet avec Chet Baker, il fit la connaisssance de Richard Bock, fondateur du label Pacific Jazz qui en était encore à ses balbutiements. Claxton en devint le directeur artistique ; les années qui suivirent, il conçut de nombreuses pochettes de disque révolutionnaires. Après avoir troqué son Speed Graphic contre un Rolleiflex, il se mit à travailler sans ajouter à la lumière du lieu d'autres sources d'éclairage. Parmi toutes les images qui ont défilé devant son objectif, beaucoup sont devenues, depuis, les emblèmes incontournables de l'époque. Ce n'est pas la sonorité des grands musiciens que capturait Claxton, mais leur âme : la puissance de concentration de Miles Davis, le cœur et l'esprit de Bill Evans qui imprégnaient ses notes de piano, la fragilité de Chet Baker cherchant son micro à tâtons, ou l'exubérance de Louis Armstrong. Les clichés de William Claxton ont été publiés dans de nombreux livres depuis les années 50. Le dernier ouvrage paru, également aux Editions Taschen, constitue l'anthologie la plus complète à ce jour. Encore aujourd'hui, Claxton continue à établir des contacts avec les nouveaux venus sur le circuit du jazz et à trouver chaque fois *la* prise de vue idéale. Devant ses clichés, c'est l'œil qui écoute.

"Photography is jazz for the eye"
WILLIAM CLAXTON

william claxton's jazz photography
c. 300 pages, c. 240 ills.
ISBN 3–8228–7868–5

Also available from Taschen:
Ebenfalls erhältlich bei Taschen:
Egalement disponible chez Taschen:

WILLIAM CLAXTON'S JAZZ PHOTOGRAPHY
The beautiful new collection of the best of
William Claxton, the world's most celebrated
jazz photographer. This book contains the
definitive icons of the American jazz scene
from the early 1950s onwards.

Die Auswahl der besten Fotografien von
William Claxton, dem bekanntesten Jazzfoto-
grafen der Welt. Diese Buch zeigt die definiti-
ven Foto-Ikonen der amerikanischen Jazz-
szene von den frühen 50ern bis heute.

Les meilleures photographies de l'exception-
nelle collection de William Claxton, le plus
connu des photographes de jazz. Dans ce
volume, vous retrouverez les emblèmes incon-
tournables du jazz américain depuis les
années 50 jusqu'à aujourd'hui.